FACE ON

BLACK DOG PUBLISHING LIMITED

FACE ON: PHOTOGRAPHY AS SOCIAL EXCHANGE

EDITED BY MARK DURDEN AND CRAIG RICHARDSON

CONTENTS

INTRODUCTION

The essays in *Face On: Photography as Social Exchange* critically examine the relationship artists have with the subjects they represent. The evidentiary status of the primarily photographic works examined here presents the artist and viewer with both a fascinating but difficult encounter. The face of the other, with which we are repeatedly presented, calls upon us to think about the context for the meeting between artist and subject, the possible motivations and desires signalled by this turning of the camera face on to the realities of other lived subjectivities: motivations and desires that are never easily pinned down, and which suggest, to differing degrees, varied relationships and feelings – exploitative, respectful, disempowering, empowering, cruel, loving, ethical, aesthetic and so on.

As artists used photography to place accent on the often shocking power of the medium's referentiality, so discourses about photography in the 90s came increasingly to be dominated by questions of the real. Questions of the real arising from the work considered in these essays concern the common and more everyday sense of a social real. What social exchange does the action of taking another's photograph actually amount to? How can this often brief encounter allow for the possibility of feeling for others, enable a consciousness of how others live and engage with the world? How effective are portrait photographs in revealing the subjectivities they purport to represent? The essays which follow take up such questions in reviewing the current vogue for a portrait-based photography, highly conscious of documentary modes of solicitation and address.

NEGOTIATING POWER

JOANNA LOWRY

In 1973 Laurie Anderson produced a work called *Object/Objection/Objectivity* in which she took ten photographs of men who had approached her or hailed her in the street:

> The daily unsolicited comments (of the 'hey baby' type) were attempts at turning me into an object to be coolly assessed. One day in the middle of June, I took photographs of the ten males who approached me in this way. To my initial disappointment, and ultimate interest, most of them seemed pleased and flattered by the 'honour' which began as an assault.

The photographs were each presented with a caption describing the incident and logging the ambivalent relationship between the photographer and the subject:

> This boy was crossing Houston Street with a group of friends. He leaned near me and said 'I like you Mama' When I asked to take his picture, he seemed embarrassed. His friends yelled, 'Hey Carlos! That lady likes you!' He insisted on posing for the picture and motioned his friends out of camera range.[1]

The photograph is revealed as a tightly focused space of negotiation within which the politics of looking and posing, of sexuality and the street, is played out. In the exhibited picture Anderson has the last word: blanking out the eyes of the subject, preventing him from looking back. This image is not a portrait of a boy, it is the record of a social encounter. In a strange and ironic sense it is the product of a kind of dysfunctional collaboration around the taking of a photograph.

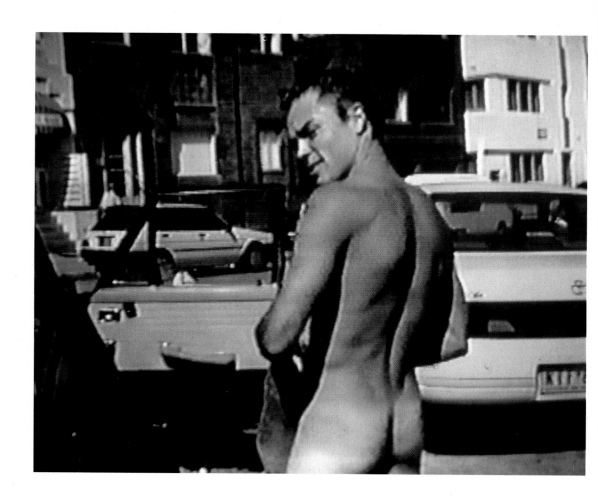

A similar set of issues was raised nearly a quarter of a century later in the video *Heaven* made by the Australian artist Tracey Moffatt. Moffatt took her video camera to Bondi Beach, centre of Australian surf culture. Central to surfing culture is the establishment of the beach as a kind of stage for the presentation and theatricalisation of the male body as the object of a sometimes narcissistic desire. Beautiful young men with oiled skin flaunt and parade their bodies in front of each other. They pose with their surf boards, they undress ostentatiously: they are on display. Moffatt followed these young men aggressively with her camcorder. At the beginning of the film they seem interested and flattered by her attentions. As time goes by they become discomfited by the persistence of the camera, by this female gaze that follows them wherever they go, that moves closer and closer, that seeks to peer behind their towels as they change. In a desperate attempt to deflect the gaze they flash their genitals at her – but this, after all, is what she is trying to see and the power of the phallus evaporates in a confusion of embarrassment and desperation.

In these two very different pieces of work the relationship between the photographer and the subject is highly sexualised. In each case what we are witnessing is an upturning and reversal of the gendered power-relations of visual space in modernity: a recognition that the public spaces of the street and the beach are spaces of contestation. In both works there is a play on the narrow dividing line between objectification and celebration, between photography as a medium of oppression and as an honorific tool. Both expose the fact that the very act of posing for a camera is always situated within a social relationship between the photographer and the subject – a moment of exchange. Within the cultural economy of the image the pose represents the point at which value is set. This is the moment of transaction when the deal has finally been struck.

Our common understanding of photography as a form of 'image-making' is undercut by practices like these which emphasise it as a dynamic practice or intervention. Central to our understanding of the image is the specificity of the social context within which it was made. The act of taking the photograph is a communicative act in itself which exposes the social dynamic through which identities (both of the photographer and the subject) are formed. Photographic practices like these which have a clear dialogical constitution seem to be more amenable to analysis as speech acts then they do as semiotic texts.

Tracey Moffatt *Heaven*, 1997, video. Courtesy of Victoria Miro Gallery, London

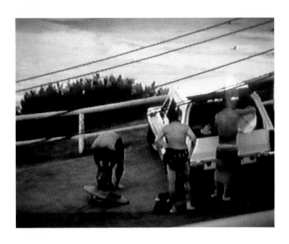
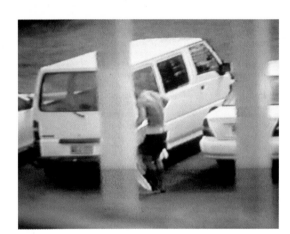

The concept of the 'dialogical' text was developed initially by Mikhail Bakhtin. Bakhtin was significant for his challenge to the structuralist analysis of language that built upon the work of Saussure. His aim was to formulate a model of linguistic analysis that took as its object not an abstract model of language as a set of rules or structural principles but language as it was produced in its materiality – as a communicative act. For Bakhtin the central unit of analysis was not the word or the sentence but the 'utterance'. The utterance that was always, inevitably, bound into a relationship between two people: that was always from somebody, always directed towards an addressee, and always anticipated a response. The utterance was determined by its particularity and by its essentially social nature. It was through the utterance, Bakhtin argued, that we produced ourselves and each other as subjects in the world and through utterances that we contested our sense of what the world itself was. In this sense language could be thought of not so much as reflective as productive and dynamic and, above all, political:

> The word is born in dialogue as a living rejoinder within it: the word is shaped in dialogical interactions with an alien word that is already in the object. A word forms a concept of its own object in a dialogical way. [2]

Although Bakhtin emphasised that at some level all language was dialogical, he was also interested in the way in which structures of power and authority were manifested in language through the degree to which it was dialogical. Implicit in the notion of the dialogical, therefore, was always the notion of the monological: that form of language at its most extreme which offered no opportunity for response, in which there was an attempt by the speaker to control the context of speech so securely as to make response impossible.

It is easy to see the relevance of this theory of language for the kinds of photographic practice outlined here. Steve Edwards has attempted to develop a Bakhtinian model of photography in his analysis of nineteenth century photography. He suggests that the photographer's studio, as a place in which the photographer has ultimate control over the representation of the subject, could be seen as a monological site par excellence, in contrast with those sites outside the studio where the photographer may have less authority and may have to be more responsive to the self-presentation of the subject:

Tracey Moffatt *Heaven*, 1997, video. Courtesy of Victoria Miro Gallery, London

The studio constitutes a monological site; for the photographer it operates as a space in which to assert mastery over the object of fascination, for repressing the uncontrolled, the accidental and the contradictory. The flux of juxtaposition and opposition that goes on outside of the studio, on the other hand, remains recalcitrant to the photographic look. Transitory and unpredictable, the spaces beyond the studio render the patternings of desire and power problematic; unlike the studio mannequin the subjects here answer back. [3]

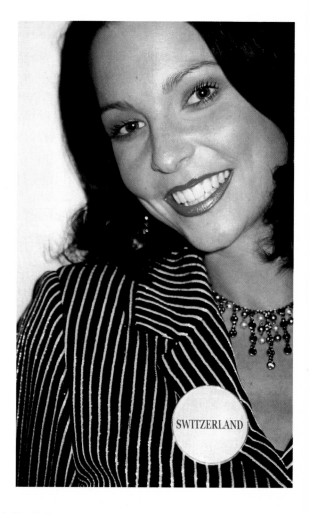

Juergen Teller, *Miss Switzerland*, 2000. Courtesy of Lehmann Maupin, New York

Clearly even this binarism between the studio and the street must break down: Edwards discusses the contrast between the 'studio' context controlled by the prison photographer in which the subject is entirely dominated by the codes of production and that of the bourgeois portrait sitting in which the subject might take a role in determining the mode of their presentation to the world. Nevertheless the concept of the 'studio' as the concrete materialisation of an abstract set of principles around power and control is a productive one. It casts an interesting light upon the latest publication by fashion photographer Juergen Teller. Teller, like many fashion photographers who are in the public eye, is plagued by endless visits from young girls aspiring to be models. They turn up, unbidden, at the door to his studio, hoping to be discovered – wanting their photograph taken. He obligingly takes their picture. Photographs of these *Go-Sees*, as they are called in the trade, have been compiled into a large photographic album. What is fascinating about this publication is the profound undecidability of these pictures, situated as they are on the very threshold of the studio. Who is really in control here? Is it Teller, with all the power of the fashion industry invested in him: his very presence coercing these young girls into a humiliating and self-abnegating masquerade, trapping them with his lens and collecting them like trophies. Is it the girls, harassing him with their constant calls, plaguing him with their insistent presence, turning his camera into a mechanism of self-defence? And what of the poses that the camera ultimately records? There is something extraordinary about this mise en scène of the doorstep in all its liminality and the way in which it instigates a kind of uncertainty around the pose. Some girls are caught off guard in all their vulnerable anticipation, others have already grabbed the moment to present the pose that they hope will launch them on their brilliant trajectory onto the fashion pages of the latest style magazine. The doorway to the studio operates as a hinge of uncertainty in the dialogic relationship between the photographer and the subject: the site itself puts into question the issue of who is in control. In a sense both the would-be model and the photographer are made visible in these photographs: both vulnerable, both in control, both negotiating the terms of their exchange around the image.

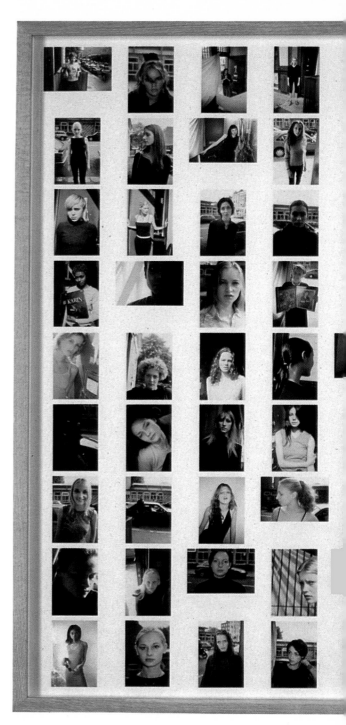

Juergen Teller, *Go-Sees: September*, 1998. Courtesy of Lehmann Maupin, New York

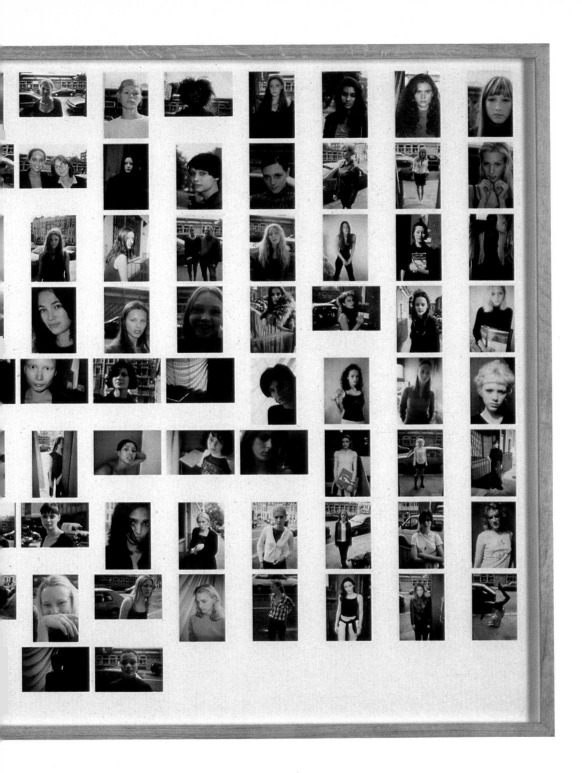

Images like these, which distil the essence of a social relationship built upon confrontation, are diametrically opposite to the kinds of photographs taken of similar teenagers by the Dutch photographer Rineke Dijkstra. Dijkstra's seemingly artless portraits also focus on the idea of liminal spaces – in one series the subjects are posed on a series of beaches around the world, in another they are posed in the back corridor of a night-club – the sense of these as spaces that are on the edge of things seems to intensify our sense of these people being somehow in-between. But these photographs are startling in their openness: the space of the photograph seems to have been produced out of a process of negotiation – the individual not so much 'taken' by the photographer as allowing themselves to be revealed. Dijkstra's video work, made at two night-clubs in Liverpool and Zaandam, is indicative of the way in which she works. Establishing a makeshift 'studio' space in the back corridor of the club she gives her subjects time just to 'be' in front of the camera – to perform themselves. There is a fascination in the way in which we see self-consciousness slowly give way to self-absorption and back again as the subjects gaze into the lens and dance and kiss and bob up and down to the music. Within this very small space of video-time a kind of authenticity of the self is revealed – not as an essence – but as the product of a dialogical process. The negotiation between self and other, private and public is made visible as an ongoing process that is integral to our sense of being.

It is only by viewing these images as the products of a negotiation in a collaborative space that we can really be open to the way in which they speak to us. Traditional semiotic analyses of the photographic image are bound into an over-determination of the visual, the image defined as a visual 'text' bounded by the frame, the process of semiosis halted by the border of the image. All that is within the frame has meaning, severed fetishistically from that which lies beyond it. A dialogical interpretation, by contrast, privileges the temporal, the borders of the image not so much enclosing and delimiting the space of the portrait but instead operating as indicators of a process. This process is not motivated by the binarism of the sign but by the slippery process of différance through which that border has been negotiated.

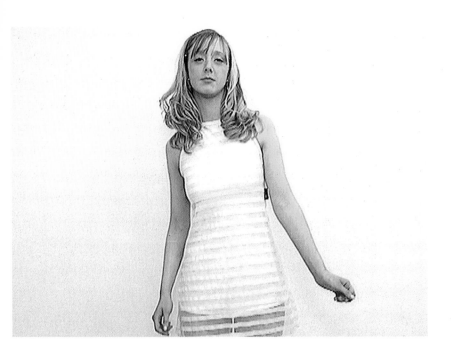

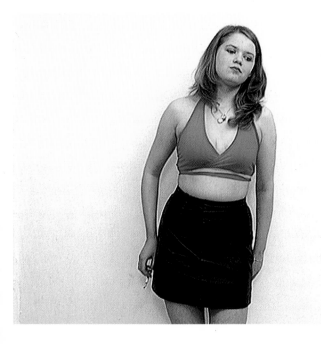

Rineke Dijkstra *The Buzzclub, Liverpool*, 1996–97. Courtesy of Anthony d'Offay Gallery, London

Such an analysis opens the image up to the 'social' in a very particular way. The concept of 'exchange' has been one of the fundamental concepts of social theory. In the 1920s the French anthropologist Marcel Mauss in his key text *The Gift* laid the foundation for a social analysis that would recognise the extent to which societies were built upon social contracts based upon exchange.[4] The symbolic power and potential of the exchange relationship was central to Mauss's analysis of social structure. What this model of social life offered was a recognition of the agency of individuals within a social structure, a recognition that was fundamental to the understanding of the way in which societies operate in time, within history. In modern societies much of the complexity of the exchange relationship is distilled into the economic language of hard currency. When we pay someone to take our portrait the power relationships behind that transaction become visible in the construction of the image, in the freedom that we have to construct the terms of our own performance. Similarly when we are paid to appear in the picture the power balance shifts and we become actors in the photographer's theatre. In most photographic work the basis of this relationship is implicit: the discursive codes of the genre are such that we immediately recognise the terms of the relationship. Two photographers who have used their work to foreground the nature of this transaction, thereby exploiting the metaphorical potential of this economic relationship, are Philip-Lorca diCorcia and Boris Mikhailov. One of diCorcia's projects involved the redistribution of a national bursary that he had been awarded to the homeless and disaffected, by using them as models in his carefully contrived photographic tableaux. If Los Angeles is traditionally the place that people go to in the hope of finding stardom, diCorcia offered them the opportunity to star at least once in his filmic narrative stills. These images, redolent with their implicit sensuality and violence, are fascinating because of the ambivalence that underpins their authorship—whose fantasy of the self is being played out? And they are always underpinned by the printed information about how much he paid the model—$15 here, $30 there, the absence of a fixed rate somehow underscoring the arbitrariness of lives lived on the breadline. How much need you be paid to play yourself in the theatre of life—what would you sell yourself into representation for?

Philip-Lorca diCorcia *Major Tom; Kansas City, Kansas; $20*, 1990–92. Courtesy of Pace/MacGill Gallery, New York

These issues become more acute in the field of documentary. Boris Mikhailov's shocking photographs of street people in the Ukraine in the aftermath of the fall of the Soviet regime are almost unbearable in the starkness of the economic truth that they represent. These are photographs of people who have fallen off the knife-edge of existence in an unstable political and economic regime. They have nothing left to lose and only their bodies to offer. Mikhailov gives them money in exchange for photographing them, stripping them naked for the camera lens. In taking these individuals to the limit, encouraging them to show us that these terrible worn bodies are literally all that they have left, he also invests them with a kind of defiance. We, as spectators, are the ones who are humiliated and degraded by the confrontation, exposed to a truth that we cannot walk away from and cannot bear to share.

These two projects add a complexity to our sense of what collaboration between the photographer and the subject involves, situating it in the wider political context of societies in which inequality is structural and pervasive. They each in their way refuse an easy liberalism of the image. The money that changes hands here symbolises the crudity of the social relationships that are supported in such a society.

Bakhtin's belief in the dialogical basis of language was rooted in a deep belief in the power of language to counter authoritarianism and inequality. Through the complexity of our language and our representational forms we could find forms of resistance, ways of speaking through the speech of others and ways of enabling other voices to be heard through our own. Language was, in essence, the product of a collaboration, produced out of difference, always multiple and heterogeneous. In a sense the photographic image has always provided us with a heterogeneous space in which the different voices of the photographer and the subject are intertwined and it is difficult to extricate one from the other. But this is a heterogeneity that should not be reduced to a kind of surface textuality – we should not see it as a problem of pictorial representation. This is a heterogeneity which is rooted in an ongoing set of struggles for power. In a way the photographers that I have discussed here have used their practice to subvert the complicity that we normally attribute to the relationship between the photographer and the subject, and to make explicit the struggles for power over the field of vision and visibility that are intrinsic to that relationship. In a variety of ways we are brought up short against the fact that none of these photographs can be read as the monological textual constructions of the photographer, they have to be seen as out-takes from an ongoing dialogical process in which the terms of our collaboration with each other are always subject to renegotiation.

1 Quoted in Henry Sayre, *The Object of Performance*, Chicago: University of Chicago, 1989.

2 M.M. Bakhtin, *The Dialogic Imagination,* ed. Michael Holquist, translated by Michael Holquist and Caryl Emerson, Austin: University of Texas Press, 1981, p. 279.

3 Steve Edwards, "The Machine's Dialogue", *The Oxford Art Journal,* 13:1, 1990, p. 64.

4 Marcel Mauss, *The Gift: Forms and Function of Exchange in Archaic Societies,* (1924) translated by I. Cunnison, London, 1969.

EMPATHY AND ENGAGEMENT: THE SUBJECTIVE DOCUMENTARY

MARK DURDEN

He doesn't want it here at the side of the house where everything is trashed and ugly, but with a good background; and in this and in the posing of the picture he gets his way.... The background is a tall bush in dishevelling bloom, out in front of the house in the hard sun: George stands behind them all, one hand on Junior's shoulders, Louise (she has first straightened her dress, her hair, her ribbon), stands directly in front of her father, her head about to his breastbone, her hands crossed quietly at the joining of her thighs, looking very straight ahead, her eyes wide open in spite of the sun....[1]

James Agee is here describing how Walker Evans takes a portrait of one of the tenant farmer families in *Let Us Now Praise Famous Men*. Evans allows his subjects the dignity of determining how they would like to be pictured. His portraits are generally celebrated for this ethical dimension, a negotiation between photographer and subject which differs from much of the other Depression photography, which instead tended to reduce the poor to a spectacle of alterity: wretched, alien, defeated and pitiable. Evans's subjects address the camera, face on, upstanding, composed and commanding respect. But while he might allow his subjects to determine how they have their photograph taken, Evans himself never shows his face. Flaubert's aesthetic is, as the photographer says, "absolutely mine: the non-appearance of author, the non-subjectivty".[2]

Walker Evans, From *Let Us Now Praise Famous Men,* 1941

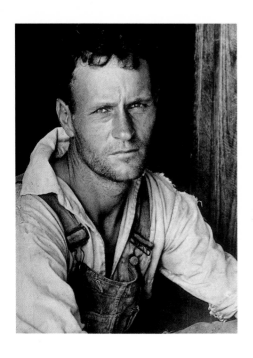

Walker Evans, From *Let Us Now Praise Famous Men,* 1941

In contrast, Agee's text represents a much more reflexive and embodied documentary. Agee desires communion with the subjects he documents through his prose descriptions, in particular in the last part of the long book –nearly 500 pages–when the writer most fully addresses the tenants. His prose avoids the expected distance and objectivity of documentary reportage. Instead the text involves excesses of subjectivity; confessional and narcissistic moments as Agee openly talks of his own feelings and desires in relation to the people whose lives he seeks to make present in his book. He thus becomes, as T.V. Reed puts it, "vulnerable in a face to face encounter". [3] Present in the prose, he gives us a very detailed account, for example, of the food eaten while staying the night with one of the tenant families, after his car gets stuck in the mud near their home late at night. Agee is careful not to offend them by showing a lack of appetite–"better to keep them awake and to eat too much than in the least to let them continue to believe I am what they assume I must be: 'superior' to them or to their food." [4] This is then followed by a vivid account of his night sleeping with all the bugs running over his body and his attempts to keep them out. For Reed, such moments involve an act of political vulnerability and communion. While under no illusions that such shared moments give him any real understanding of their lives, they "represent the possibility of understanding, begin a dialogue". [5]

While Agee's book helps define an ethical and empathetic documentary practice, certain problems remain, shortcomings which are linked to the visual and aesthetic effect of some of his prose descriptions. In many respects photography affects and shapes Agee's writing – Evans's photographs (all uncaptioned) precede Agee's text in the book. The non-narrative form of his writing, its descriptive excesses, all constitute as Paula Rabinowitz has put it, the book's "paean to the visual". [6] One can begin to understand Agee's aesthetic praise of the people, their homes and meagre belongings, as proceeding in opposition to denigration – the abuses which marked much Depression documentary as it sought out squalor, abjection, denied its subjects the respect of self-composure before the lens. Yet the praise means his prose gets caught up in a problematic aestheticising vision, one which can be seen to particularly characterise Evans's beautiful pictures of poverty. Agee's detailed descriptions of the tenant family homes and belongings underline their beauty: the partition wall of one of the families' front bedrooms is referred to as "a great tragic poem", [7] while the texture and colour of one of their worn overalls is said to achieve a "scale of blues, subtle, delicious, and deft beyond what I have ever seen elsewhere approached except in rare skies, the smoky light some days are filmed with, and some of the blues of Cezanne". [8]

Such descriptions are nevertheless edged by guilt, admissions of the privilege of an educated sight: "To those who own and create it" the beauty of the tenant farmer homes is "irrelevant and indiscernible". [9] It is only seen by 'those who by economic advantages of training have only a shameful and thief's right to it: and it might be said that they have any 'rights' whatever only in proportion as they recognise the ugliness and disgrace implicit in their privilege of perception.' [10] "I have a strong feeling", Agee even goes so far as to say that, "the 'sense of beauty', like nearly everything else, is a class privilege." [11]

Caught up in privilege, a clash of differences between documentarian and documented, questions of aesthetics remains, for Agee, ethically troubling. And all this is very pertinent to the present climate, particularly the Saatchi sanctioned vogue for the neurotic realism of certain contemporary documentary based photography practices, perhaps best exemplified by Richard Billingham's much vaunted pictures of his own family's poverty. Here we are far from the detached cool of Evans's portraits. Billingham's pictures rely on the tensions and contradictions between an essentially abject and counter-idealising vision and a pictorial richness. Much of their aesthetic effect is caught up in a class collision of taste, where the spectacle of kitsch ornamentation – legible to middle-class viewers as working class

Richard Billingham *Untitled*, 1995. Courtesy of Anthony Reynolds Gallery, London

'bad taste' – both maintains a cultural and class difference – keeps the subjects in their place, apart, separate, and yet gives these pictures their aesthetic distinction, raises them from beyond 'mere' documentary: the optical play of patterns in these photos of crammed interiors provides a beautiful foil to the expansive spaces of both galleries and wealthy collectors' homes.

Thomas Hunter's evocation of Vermeer in his portraits – recently on show with other Saatchi Neurotic Realists – is intended to celebrate the lives of squatters: the seduction of colour and the calm of the Dutch painter help make his unsavoury subject matter palatable to middle-class viewers. Aesthetics is however here also caught up in a celebration of these cultured and creative alternative lifestyles, integral to Hunter's idealising refashioning of these people against a black and white dystopian documentary view which portrays them apart, as drug-taking social misfits. Yet that there is so little anger, that his subjects are so uniformly placid is not without its problems. And one wonders whether the very aestheticised staging of his subjects, while a reversal of denigration, still maintains difference, keeps them apart. The real poverty and political struggles which mark out life in a squat are always in danger of becoming mere background to the overridingly visual effects as these alternative lifestyles are glamourised, made fashionable and chic.

Part of the problem of aesthetics and spectacle is the distance it sets up, on the part of the viewer, from documentary's social referentiality. The frozen nature of the tableau in Hunter's carefully posed and staged portraits further adds to this. György Lukács's distinction between narrative and description becomes particularly relevant here.[12] He argued that with a preference for description over narration the possibility for action diminishes. He highlighted Zola's descriptive prose as being based upon distance. Zola only 'describes' the horse race as a piece of verisimilitude, whereas Tolstoy 'narrates' the horse race as an integral part of his character's lives. Empathetic involvement was key to Lukács's description of Tolstoy, a shift from the alienation before Zola's frozen tableaux to an engagement that is more participatory. Bill Nichols evokes Lukács's distinction in relation to his critique of contemporary news reporting, the way in which events themselves become "only a tableau for the reader, or at best a series of tableaux."[13] We are merely observers to the news, which is seen to exist "less to orient us toward action than to perpetuate itself as commodity, something to be fetishised, consumed."[14]

Tom Hunter *Woman Reading Possession Order*, 1998. Courtesy of The Saatchi Gallery, London

Subjectivity and identification are much more frequently explored in fiction than documentary. Agee's book is, then, an exception, empathy and engagement become central in his attempts to convey the lives of an "appalling damaged group of human beings". [15] *Praise* helps define the lack and problems within current documentary photography practice in which aesthetics tends to function to screen and filter us from a lived social reality, inculcating a disengagement, a lack of empathy on the part of the viewer.

If *Praise* is marked by a self-consciousness about the cross-class looking on the part of its privileged Harvard-educated white author, the Chilean-born artist Alfredo Jaar presents the viewer with the discomfiture of cross-cultural looking, sets up situations which confront us with the differences between 'our' first world and the so called third world, forces us to look into the faces of the displaced, disempowered and under-privileged.

Jaar's *One Hundred Times Nguyen*, offers various permutations, in its sequencing, of a quartet of portraits of a little girl Jaar had met and photographed in a refugee centre in Hong Kong. Jaar's use and display of such portraits is to be set against the often distancing and disengaged effect of news reporting. The sentimental pull is deliberate, as is the strategy of repetition, an insistence that we look into this little girl's face over and over, a process of reiteration which is intended not to drain empathy and affect out of the picture, but facilitate a slowing down of our relation to an image and thereby countering what he describes as "a media landscape filled with thousands of images, all fighting to get our attention, and most of them asking us to consume, consume, consume". [16]

"How can an image of pain, lost in a sea of consumption, affect us?" Jaar's question helps explain the use of hyperbole and repetition, not only in *One Hundred Times Nguyen*, but in particular with the way he addresses the horrors of the Rwandan genocide. In many senses his extraordinary installation, *The Eyes of Gutete Emerita* is to be set against the media reduction of genocide in Rwanda to a spectacle of horror, with the visibility given to foreign bodies in Western media serving as signs of a barbaric third world to 'our' civilised West. With its display of a million identical slides on a table lightbox, Jaar does not show the horror, but gives us instead a close-up of the eyes of a young Tutsi woman who had witnessed her family being massacred. Jaar calls attention to tragedy indirectly, through an elliptical installation centred upon an imploring eye-to-eye look. The installation reverses the logic of media reporting where as Jaar puts it "we are given the sense of being present and living the information we are provided with, but once the TV is switched off, we are left with inescapable sense of distance... the media offer images which give an illusion of presence, which later leaves

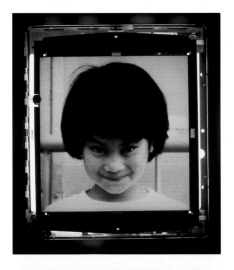
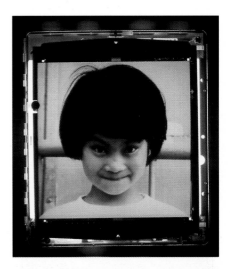
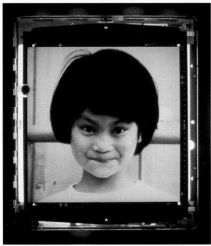
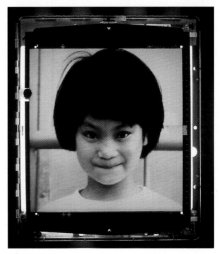

Alfredo Jaar *Four Times Nguyen*, 1995, film in Quadvision. Courtesy of Gallery Lelong, New York

us with a sense of absence." In *The Eyes of Gutete Emerita* what he does is to "offer an absence that provokes a presence".

Documentary negotiates difference and the ways in which this difference is negotiated determine its political effectivity. Tensions and conflicts invariably run through documentary practice, as one person seeks to represent the life and experience of another. Jaar's strategic use of photography forces us to acknowledge cultural distance and difference, the boundary between my comfortable Western reality as viewer and that of the under-privileged individuals photographed. Insistence on the eyes of Gutete Emerita – a photographic cliche as a sign of empathy – is a call for identification, an inter-subjective appeal which forces us to try and begin to imagine the appalling horror witnessed and the pain she suffers. A fundamental concern as Jaar has said is to establish a dialogue with his audience, "they complete the work, move it from 'theory' to the world of practice that makes it 'real'." "Each work must suggest and try to create a new model, a paradigm of social participation."

Jaar might work against photojournalism and documentary, but his basis is in documentary, as the photographs are grounded in the experience of gathering evidence for his art on site; he gets as close as possible to realities other than his own. He remains aware such experiences can never be adequately represented. He can only create new strategies of representation. The excesses of repetition both in *One Hundred Times Nguyen* and *The Eyes of Gutete Emerita*, are such strategies, installations which intended to set up an active rather than passive relationship to the viewer; the rhetorical beseeching form of the work is intended to shake us out of comfort and complacency and in the case of *The Eyes of Gutete Emerita* avoid spectacularising horror. There is always a need to go beyond the form of art, whatever the medium and whatever assumptions might be made about its worth as evidence.

While writing, often exhaustively, of everything which only in actuality or in the mind happened or appeared, James Agee still openly admitted he never would be able to give us the truth of the lives of those he describes in *Praise*. Acknowledging its failures, inadequacies, and incompleteness Agee's text ultimately remains more engaged than Evans's pictures. While drawing attention to *Praise* I am looking back to a moment in documentary history, but a moment crucial in understanding the very real and difficult social exchanges which have to be negotiated in documentary making today. *Praise* helps us rethink the idea of documentary as simply one of disengagement – the disengagement of the aesthetic spectacle of celebrated artistic forms of documentary practice, the disengagement of emotionless TV news reporting of disasters. Instead, *Let Us Now Praise Famous Men* helps us acknowledge the need for a documentary which is more empathetic, subjective, engaged. And this move to engagement, as Bill Nichols points out, opens up a space for contestation, orients us to action. [17]

1 James Agee and Walker Evans, *Let Us Now Praise Famous Men*, Boston: Houghton Mifflin Company, 1941, p. 369.
2 Leslie Katz, "Interview with Walker Evans" in *Art In America*, 59, March 1971, p. 84.
3 T.V. Reed, "Unimagined Existence and the Fiction of the Real: Postmodern Realism in Let Us Now Praise Famous Men" in *Representations*, Fall 1988, p. 171.
4 Agee and Evans, *Praise,* p. 414.
5 Reed, *Representations*, p. 172.
6 Paula Rabinowitz, *They Must Be Represented*, London: Verso, 1994, p. 11.
7 Agee and Evans, *Praise,* p. 204.
8 Agee and Evans, *Praise*, p. 242.
9 Agee and Evans, *Praise,* p. 203.
10 Agee and Evans, *Praise,* p. 203.
11 Agee and Evans, *Praise,* p. 314. One should add there is a further problem with the presence of Agee in his prose. While on one hand it is important as the writer makes himself vulnerable, shows his face, offers respectful moments of exchange – an engagement and participation providing a contrast to the visual and static effect of his camera-like descriptions – on the other hand, Agee's very excesses of subjectivity, as Paula Rabinowitz has pointed out, can mean there is a tendency to shift from an examination of the tenant families to a disclosure of self. As she says, the book "cannot escape the confessional narrative of bourgeois selfhood, the story encodes the middle class as the subject and object of its own narcissistic and self-loathing gaze." Rabinowitz, *Represented,* p. 54.
12 See György Lukács, "Narrate or Describe?" in *Writer and Critic*, London: Merlin Press, 1978, pp. 110–148.
13 Bill Nichols, *Representing Reality*, Bloomington and Indianapolis: Indiana University Press, 1991, p. 193.
14 Nichols, *Reality*, p. 194.
15 Agee and Evans, *Praise,* p. 7.
16 All quotes by Jaar, unless indicated, taken from Anne-Marie Ninacs's interview "The Responsible Gaze: A Correspondence with Alfredo Jaar" in *Le Mois de la Photo a Montreal*, 1999.
17 Nichols, *Reality*, p. 114.

REALITY GAPS, ASSUMED AND DECLARED

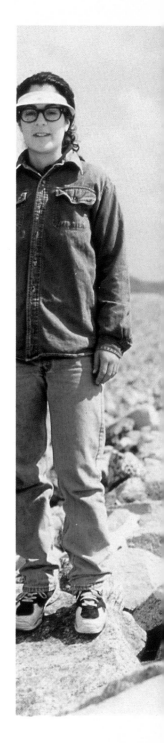

CRAIG RICHARDSON

I am an artist, I am working on a project where I am taking pictures of myself with people I don't know, but making them look like they are family pictures, and will you be in the photograph. [1]

Although many artists have shown a concern with abjection and dispossession, many contemporary photographic portraits do not attempt to instil in the viewer any sympathetic affinity with their subjects. In evidence instead is the suggestion of arranged intimacy between the artists and their images' participants. Created through deliberate organisational frameworks these photographic portraits show a knowing presence of the artists' intentions in their participants' 'responses'.

These are surprising and often, photographically speaking, unfamiliar, encounters, sometimes set in a barren but not always hopeless space, between the interlopers and the camera. To the viewer the participants depicted may only amount to a magnification of the face in a crowd. But these are after-images of events in which participants were sought out, where the reaction time of the act of the photograph was preceded by a mostly spoken and sometimes realised statement of conditions, of obligation, of payment, of curiosity. As in a series of works from 1994 by Alfredo Jaar which figure the wary glance of Nguyen Thi Thuy, a Vietnamese asylum seeker in a Hong Kong detention centre, our relations with our 'neighbours'– 'the foreigners', the forgotten, the untouchables – are depicted in these images.[2]

As the established descriptions of territory, privacy, difference and nationality change, the critical issue is how we construct communities. It is in the description and the creation of encounters in a created *photographic social space* which cut into communities or networks of people that Jaar, and other artists, show the condition of the dispossessed to be unacceptable.

Crucially, attention to the 'sites' we can develop and create—domestic, sexual, racial, cultural and 'imagined'—incur continued critical examination as exploratory sites. While it is the case that many artists forefront the existence of the dispossessed for intended political effect, an apparent sense of anomie, humour and transgression evident in the work of many younger artists alleviates the viewer from the seeming hopelessness of exclusion from basic human rights. (Rights which, oddly enough, change definition depending from which nation's mountain one is looking down from.) Rather than shifting the frame to document the socially excluded many younger artists readily stand within their constructed images, extending reality. This approach continues to highlight the false construct of objectivity in documentary photographic practice. In recent correspondence the artist Adam Chodzko describes the necessity for this approach:

> As spaces that surround us are unstable and open to possibility and exploration… it is very important that we as a public initiate this play and treat art as a way of being active in the world rather than believing that these structures are fixed and that our role is purely that of audience and illustrator. [3]

While acting with some sympathy for his participants Philip-Lorca diCorcia's *Hustler* series works within and against a traditional documentary paradigm through a careful insertion of reality into visually seductive constructions. These acts of desire and fantasy (on the part of both named 'sitters' and diCorcia) are played out against a documented reality of consumption and monetary exchange. The titles of the works label the images in conventional portrait manner and yet, oddly, conclude in a quantity of dollars. The dollars in the work's title are a fee diCorcia paid his participants to pose for him, to be illuminated by the fast food signs or logos of contemporary urban living. Works such as *Brent Booth; 21 years old; Des Moines, Iowa; $30* offer portraits of men diCorcia presumed to be male prostitutes, drifters and drug addicts, images constructed as day becomes night in the boulevards of Hollywood. The chiaroscuro of these beautiful works are illuminated slow realisations of failed dreams at the journey's terminus, the return ticket home being the only escape. And in the participants response to diCorcia's request for involvement—their moment—in his theatrical events, in the paltry (although maybe much needed) payment, there is a suggestion of the grave.

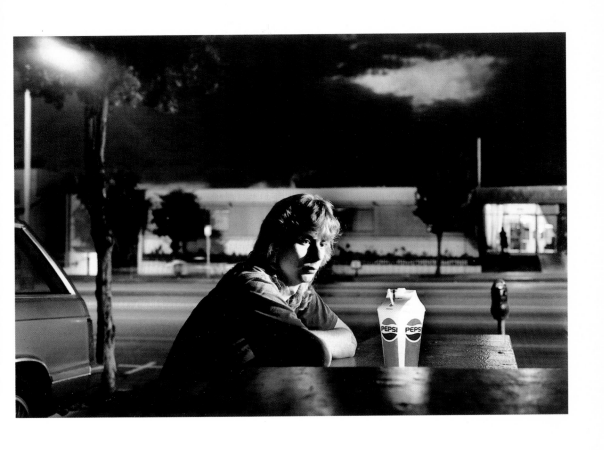

Philip-Lorca diCorcia *Brent Booth; 21 years old; Des Moines, Iowa; $30*, 1990–92. Courtesy of Pace/MacGill Gallery, New York

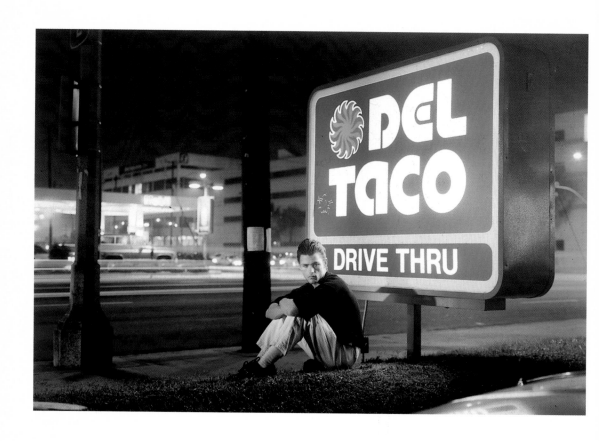

Philip-Lorca diCorcia *Ralph Smith; 21 years old; Ft. Lauderdale, FL; $25*, 1990–92. Courtesy of Pace/MacGill Gallery, New York

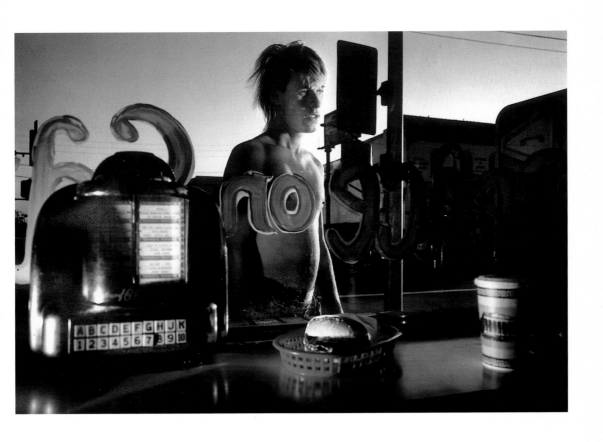

Philip-Lorca diCorcia *Eddie Anderson; 21 years old; Houston, TX; $20*, 1990–92. Courtesy of Pace/MacGill Gallery, New York

Using a completely different strategy to fend off dejection in the practice of documentary activity, Mierle Laderman Ukeles forefronts the experience of the sanitation workers in New York. Made in her unofficial capacity as their artist-in-residence *Touch Sanitation: Handshake Ritual* is the resulting documentation from a city-wide performance involving 8,500 sanitation workers. Dismayed by the low status and derogatory treatment of 'sanmen' Ukeles countered with thousands of handshakes as a gesture of recognition, with a camera nearby to capture the 'touch'. The performance was both a map of work in modern society and an attempt to enhance public life, with resulting documentation resembling the images of the crowd pleasing, 'flesh-pressing' rituals employed in modern democratic politics.

While *Touch Sanitation: Handshake Ritual* results from a consideration for others who shovel our dirt the art work exists through the tight administrative framework of geographic survey. The holding of many thousands of hands and the campaigning travel arrangements mirror the logistics of the usually unseen sanitation disposal routes. In representing a sizeable shift of earth through various locations *Touch Sanitation: Handshake Ritual* could be viewed as a work of Land Art whose existence can be verified through its documented socially visible element – the people who collect and dispose of the garbage. In Ukeles' work the making visible of maintenance processes and sustainability in 'peopled' environments is a political necessity so often avoided in other social spheres.

Ukeles' work shares with Alfredo Jaar's a necessity to explain to participants the work's purpose which must at times result in a pragmatic, rather than sentimental approach. Direct engagement with participants produces persuasive evidence which meet the artists' expectations that art affects the worlds it inhabits (even if a 'declaration' or assertion of reality is fraught with difficulty). It would therefore be a disservice to the audience of the artworks or documentation if the artists were to simply adopt the emotions of their participants.

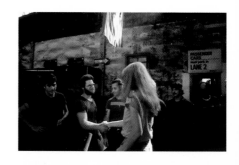

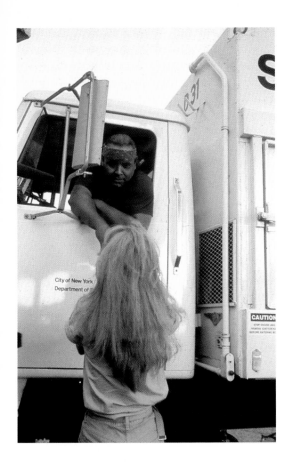
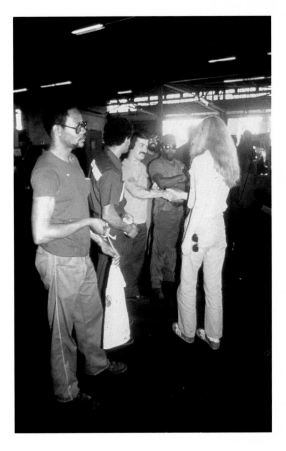

Mierle Laderman Ukeles *Touch Sanitation: Handshake Ritual,* 1979–81, Courtesy of Ronald Feldman Fine Arts, New York

Roderick Buchanan *Me and my neighbours,* 1994

In the work of the Scottish artist Roderick Buchanan association, using the signs and production of global activities, as in such recognisable team/group activities as football, are counterposed with our less than ideal or inadvertently humorous attempts to personalise or incorporate these in our everyday lives. To this end his video, photography and text works position possible cultural knowledge and difference between his participants and his works' audience as desirable. His work remakes definitions of collective enterprises, given identities or 'allocated' spaces whose assumptions we are encouraged to keep.

The measured space between Buchanan and his neighbours in the work *Me and my neighbours* is crucial to the understanding of this image and his modus operandi. The favoured gap is not a space of acceptance or rejection by his neighbours towards him (or vice versa) but rather Buchanan's test of his audience's liberalism through a presumption of closeness towards his 'neighbours'. Furthermore, the space he has created and in which he co-habits is the photographic structure of the family portrait within which he has also introduced an unusual sense of separation, himself. Buchanan's hands are in his pockets, the others stand or sit with respect towards the formality of the moment, the sons stand attentively, the parents are neatly seated. Buchanan is inclined insouciantly towards the family but outside of it, skewing the photograph, having devised his presence as an extension to the familiar. The work speaks of a social life which has moved considerably beyond simple limited respect or blind acceptance of ethnic diversity, towards other, different, constructions.

Similarly, Jennifer Bornstein's self-portrait works, *Interventions*, feign the look of intimate relationships but are photographic actualities revealing her presence in the images as an interloper. Her documented vulnerability, as a young woman as much as a photographer, is evident in works which mimic the closeness of family portraits but have other uncomfortable parameters (in that she approaches strangers and invites the pretence of a familial or physical bond). In *Interventions* the visible closeness of the participants and her pensive non-self are barren arrangements in the middle of empty, rocky park lands, nowhere in particular. Here is the deliberate removal of identity and its replacement with a sequence of false alliances and friendships. Of her fellow portrait sitters Bornstein alludes to a disturbing synchronicity of place (Los Angeles) and possible human interactions (tracking strangers, pensive relationships), and states:

> I never felt a connection with these people. One guy, I don't think we spoke two words to each other. I wanted to be straightforward about it but the fact of the matter is I was using these people, sort of manipulating these people into touching me for these photographs. [4]

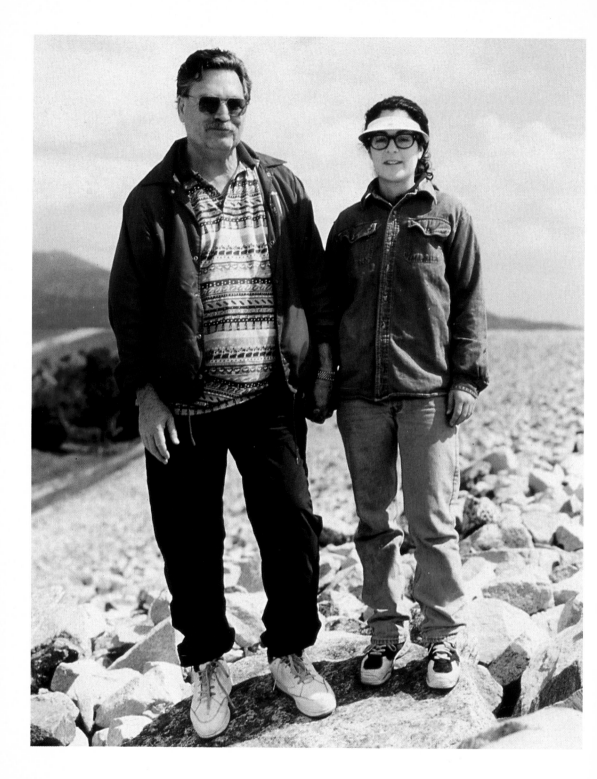

Jennifer Bornstein *Intervention no. 2 (Hansen Dam, San Fernando Valley),* 1999; *Intervention no. 4 (Lake Balboa, Rec Center, San Fernando Valley),* 1999; *Intervention no. 7 (Griffith Park, Los Angeles),* 1999. Courtesy of greengrassi, London

Using a pre-existing filmic site as a fabrication to explore Adam Chodzko's video work *From Beyond* brought together, through the event of a reunion, uncredited extras from Ken Russell's controversial film *The Devils*. Chodzko has them address to camera their recollection of their role in the film, often recounted as an intense series of personalised events, an intensity given, as Chodzko states, through "Cinema, and other forms of reality, which like memory or fantasy are spaces which move in and out of each other as we try to live." [5]

As the work develops these middle-aged figures become incorporated in their filmed past: as they tell their story they are enveloped by the screen showing the film behind them, we see their past selves writhing naked in moments of orgiastic abandon, falling into death pits, tearing their clothes apart. Chodzko treats the original film as a solid form which can be handled intimately, whose participants' attention, as extras, is on a moment passed. [6] The moment was a particular and transitory expression of Ken Russell's and *From Beyond* reprioritises his attempts at directing our attention and instead pulls us towards the periphery of film, namely the experience of extras, which for Chodzko "are the most real aspect of the film, they run amok as a surging crowd, which is what they are." [7]

In the extras' involvement with *From Beyond*, there is the possibility of retrieval in their act of recollection. Through physical separation, and time, visibly enhanced by the extras' contemporary middle-age appearance contrasted with their younger selves emerging from beyond the temporal space of *The Devils*, "there is a kind of classic haunting; a reality which was ignored at the time, declaring itself in the present." [8]

1 Jennifer Bornstein, in discussion with the author, 10 June 2000.
2 The place and conditions require hesitancy in the artist's approach. Indeed one of the works, *One Hundred Times Nguyen* senses the doubt of the artist of his practice. Some sense of reconsideration that a close encounter with the misery caused by the exclusionary practices of a nation-state occurred through this 'taking' of a child's photograph. It may be that the doubt extends not only to Jaar's photographic practice but also the nature of participation with others in his work. Collectively it is a doubtful image, circumspect in its final resolution whereby the roundness of the title's number is not even found in the actual work, which has ninety six variations of a portrait in a variety of sequences and four blank spaces. And yet the repetition of a smile in Nguyen's face mitigates against these problems, so far removed from the journalistic reflex of most mass media imagery.
3 Adam Chodzko, in correspondence with the author, 14 June 2000.
4 Jennifer Bornstein, in discussion with the author, 10 June 2000.
5 Adam Chodzko, in correspondence with the author, 14 June 2000.
6 In reply to question as to the extras' motivation in participating in *From Beyond* Chodzko remarked that "very few of the people who returned from this space (*The Devils*) 25 years before had actually seen *The Devils* as the completed film. I don't think it was due to any trauma it was just that their participation as an extra completed a relationship with that space and there was no need to see how they were included in its final reality."
7 Adam Chodzko, in correspondence with the author, 14 June 2000.
8 Adam Chodzko, in correspondence with the author, 14 June 2000.

Adam Chodzko *From Beyond*, 1996, video

CONTRACTUALITIES OF THE EYE

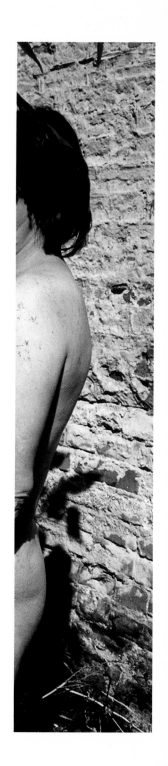

IAN HUNT

We shall thus achieve a dual purpose. On the one hand, we shall arrive at conclusions of a somewhat archaeological kind concerning the nature of human transaction in societies around us, or that have immediately preceded our own. We shall describe the phenomena of exchange and contract in those societies that are not, as has been claimed, devoid of economic markets – since the market is a human phenomenon that, in our view, is not foreign to any known society – but whose system of exchange is different from ours.[1]

What kind of bond with the subject can the photographer claim through an activity that, though it may be clarified verbally, is usually only a fleeting agreement, with no check possible on whether the resulting image is to be used for purposes of fair dealing? The most important aspect of the photograph is its exchange of interest with the viewer, but the agreement made with the subject is nonetheless indicative of the kind of society in which it is made. The photographer Boris Mikhailov has made a notable series in his native city of Kharkov, Ukraine, of those people who maintain themselves on its streets or in severest poverty. Collectively titled *Case Histories*, the photographs often show subjects naked or partially clothed. To explain something of the power of this series we need to consider not just its considerable shocks, nor even the trust that Mikahilov gains as one locally born, if now living abroad. He is not a superbly professional informant, publishing a level of Ukrainian society to a wider audience so that it can merely look into the abyss and walk on. The photographs have a closeness to their subjects not born of a need to empathise across an unknowable social gulf, but one owing to the very recentness of the failure of formal legal responsibility of the state for all of its citizens that has created this new class of persons. And they are still persons, persons who look back as much as they are looked at.

Mikhailov pays his models for their co-operation, and indeed he has sometimes faced the uncomfortable task of turning away those who found their way to his door in the hope of payment. A 'person' was defined by Roman law as he who is capable of owning things. The definition has had a remarkable longevity. Poverty photography's usual trick is to depict those dispossessed or in need of alms as naked, deprived of possessions and at the same stroke of personhood, of needs other than clothing or food. The nakedness of Mikhailov's subjects has been arrived at as a result of contract and negotiation, activities in which a reduced but recognisable humanity resides. Mikhailov explains:

> Manipulating with money is somehow a new way of legal relations in all areas of the former USSR. And by this book [Case Histories] I wanted to transmit the feeling that in that place and now people can be openly manipulated. In order to give the flavour of that time I wanted to copy or perform the same relations which exist in society between a model and myself. [2]

There is the question of photographic culture to consider too, as the critic Gilda Williams notes.

> Theorist Pierre Bourdieu has famously analysed the ordinary use of household photography as "solemnising and immortalising family events". Yet in the Soviet Union, home photography was for many years off-limits and very few family photographs exist; for this reason critic Viktor Misiano has described Mikhailov and subsequent generations of photo-based artists as "photographers without photography". Mikhailov chooses to shoot the bomzhes [homeless] when they are still fresh to the group, as yet not hardened beyond recognition – as one photographs newborns arriving in the family. This would position Mikhailov not as an outside observer but as the documentarist embedded within the family itself. [3]

Boris Mikhailov From the series *Case Histories*, 1998. Courtesy of The Photographers' Gallery, London

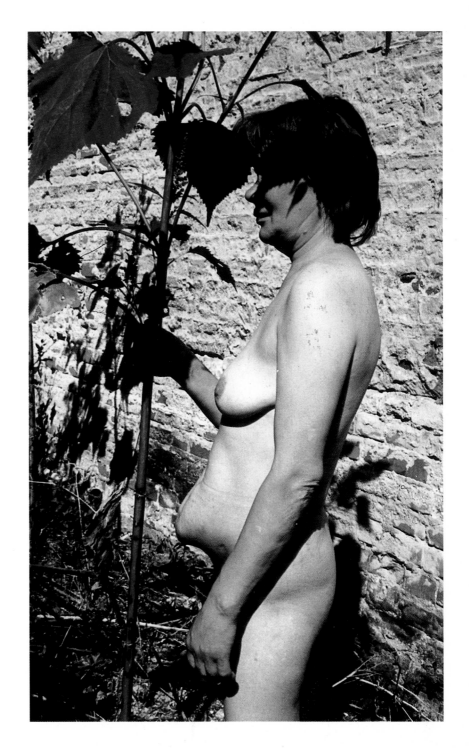

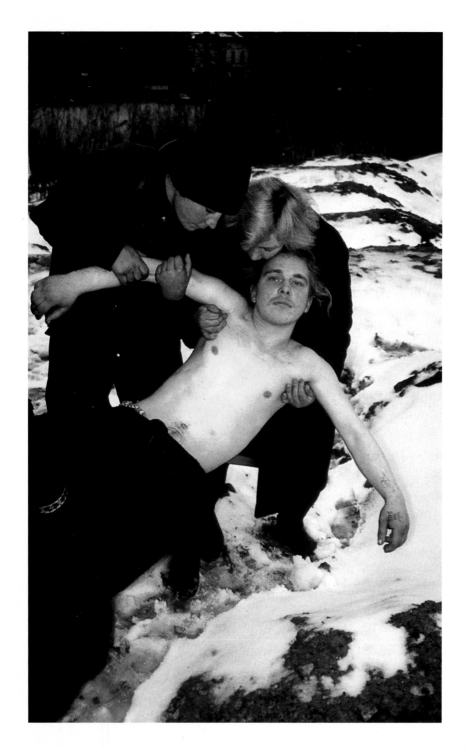

What Mikhailov captures is the early progress of an idea of the self as merchantable, before the new classes that have come into existence, rich and poor, have fully established and internalised their rules of behaviour as a clan. It is the very uncertainty of the new economic morality as it is being learnt that leaves a remainder of human interest, a surplus for both the models who pose themselves and for the viewers held by the image.

Over in Los Angeles – which figures, for now, as an ideological terminus though it could be elsewhere – the basketball kids and family groups who agree to be photographed with Jennifer Bornstein may not understand all the rules of the contract they are getting into. And they are not getting paid (being photographed isn't so arduous an experience after all; a few seconds might be all it takes). But they understand it well enough to know they are not losing out, that what they are having is a kind of fun, a non-threatening disruption of the social equilibrium of pretending to ignore others that reigns elsewhere. That equilibrium is perhaps even more delicate in places such as public libraries and community basketball courts, places Bornstein makes her fleeting associations, in that these are where forms of association with others may be sought.

We do have strange laws governing the use of the eyes in public places. It is more than unmannerly in many large cities to solicit a stranger's eye too familiarly when out walking; it is the mark of the incomer or the country bumpkin, unused to the peculiar contractuality of the eye in city life. A sense of collective safety is reinforced more by routinised avoidance of eye contact than by unexpected greetings and familiarity. The contract is unwritten, it has grown out of customary practice and been learnt – watch those too young to have perfected it – by children. It is not observed equally by all. But acceptance of it is so wide that perhaps in many people's minds it is elevated to a rigid rule. A simple inquiry may often be felt to disturb the equilibrium and to be a cause for alarm. Indeed parts of the contract that people sometimes need retraining in are those sections treating when it should be waived.

Boris Mikhailov From the series *Case Histories*, 1998. Courtesy of The Photographers' Gallery, London

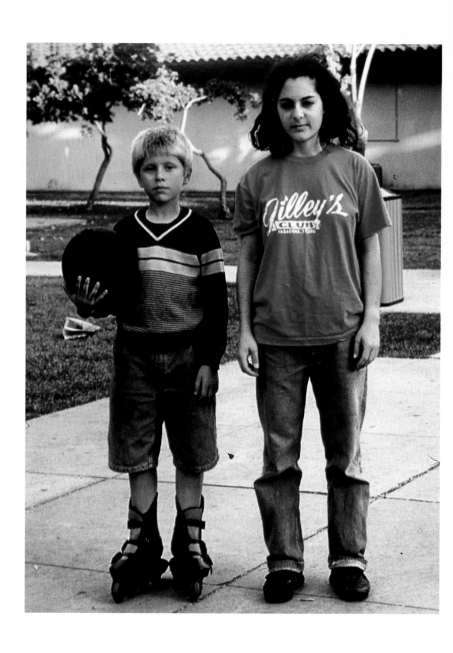

Jennifer Bornstein *Fuller Community Recreation Center Basketball Court, Fuller Street & Santa Monica Blvd, Los Angeles,* 1996–97. Courtesy of greengrassi, London

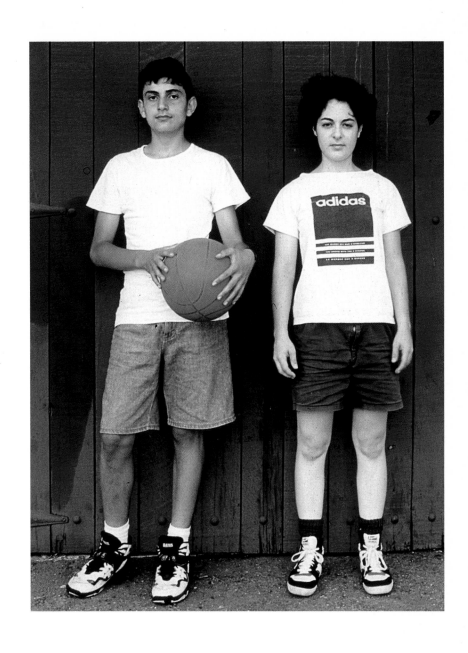

Jennifer Bornstein *Poinsettia Community Recreation Center Basketball Court, Poinsettia Street &*
Willoughby Avenue, Los Angeles, 1996–97. Courtesy of greengrassi, London

The figure of a person with a camera changes this situation a bit; the camera is part of the regalia of leisure. Away from situations where the camera lens is pointed directly across a barrier of inequality – a situation where the model or subject may be forearmed with suspicion, or may yet perform freely, and feel recognised and legitimised by the transaction – the kinds of contractuality emerging may take a form of respect for another behind which the artist's motivation remains obscure. However, the cumulative effect of looking at Bornstein's accomplished self-possession in the resulting photographs alongside the varied bodies and expressions of adolescents is that others are being brought into the gallery according to formal rules the artist and the viewer share. The somewhat impersonal authority of the serial imagery reveals itself in the gallery more strongly than it does to the participants of Bornstein's series, as they take part. That does not mean they are being manipulated – as Mikhailov explicity does manipulate, for particular historical reasons. Rather that Bornstein's authorship is to be found in what cannot be regulated in the fleeting encounters as well as in the enabling architecture of those encounters she has set up.

Risking generalisation, these transactions with others – in the works of Bornstein, who resembles a market researcher mysteriously lacking an object or marked by the buying of co-operation on unequal terms in Mikhailov's – can be seen as commentaries on contractuality in their respective societies. These blips of the social process arranged around a camera are a small part of the discussion of the ways in which we can expect give and take with strangers. What is striking in Bornstein's work is the constraints curiosity appears to operate under. Of course these transactions are not themselves contracts, in the normal sense of the word. But they do represent exchanges of interest and an opening of art to representations of specific social groups that – in that it is done in a systematic fashion – become parts that recall the whole, and the current state of it. The respect we owe to strangers is a measurable part of the strength of a society's culture and self-understanding.

Marcel Mauss saw his social researches into non-marketist, non-utilitarian forms of exchange in traditional societies – contests in which honour was always strongly at stake – as finding a distant counterpart in the developing idea of national insurance, something that had only properly emerged in Europe in his own time. National insurance is a system of payments equalising fate for those unlucky and also a form of care that did not, like charity, bring unwelcome forms of obligation; there was, and is, a recognition of oneself in the state that repays and readministers what one already owns, and therefore a modernised form of honour. In present social arrangements within many democracies the contract with the state has come to appear relatively insignificant as compared with those of the market, in which the more powerful players have learned how to buy loyalties and to tame antagonism and also honour. We are encouraged to recognise ourselves as represented within the agency selling and delivering services; and these kinds of identification come to seem more telling about the kind of lives we lead than political choices. The constant nagging at our attention and insinuation into consciousness of contemporary capitalism often leaves behind an unacknowledged annoyance that we are being coerced into paying attention, placed under forms of obligation to respond that we cannot negotiate away. (Junk mail still appears to us as a letter, something in which we hope for news.) The social horizon I want to emphasise here, although it is part of a complex development which includes the rise of the discourse of safety and security, is that attention and curiosity about the world and about others has been placed under strain, to some extent shut down in our actual dealings with others by these arrangements. Meanwhile the TV documentary tradition has reinvented itself to offer compensatory forms of knowledge and intimacy with strangers; a route many artists have also embraced in their depiction of their society, though not the ones discussed here. Either way, the conditions don't seem to be in place for a reinvention of the humanist tradition of documentary.

It is perhaps not unfair to point out that the figure of the artist as interloper, as researcher that has emerged in recent years, has frequently been accompanied by the adoption of an impersonality of presentation whose origins are somehow beyond questioning, however idiosyncratic the research programme itself. It is almost a contemporary sign of an artist at work. The best artists have employed impersonality to effect, not as unexamined rhetoric, and also know that it has already acquired an extensive aesthetic history. Also working in Los Angeles, Sharon Lockhart has made works in which collaboration with others — notably teenagers and children — often features. In one series, *Audition*, pairs of children acted out the kiss from Truffaut's film *L'argent de poche*; kissing being one of those experiences that are borderline experiences for actors, and whose practice is strongly influenced by filmed portrayal.

More recently Lockhart has made three series of works in Brazil, published in *Teatro Amazonas*, in which she shadowed two anthropologists.[4] On one trip a study was being made by Isabel Soares de Souza of kinship groups on Apeú-Salvador, a tiny island near the mouth of the Amazon in the province of Pará. Lockhart solemnified the encounters by photographing formal family portraits in classic black and white; three in each case, shot with a large format camera and printed to a size neither small nor large (approximately 80 x 70cm). Polaroids, technically Lockhart originals, were taken as part of the process by which the subjects composed themselves for the camera to their satisfaction, and as is very often the case, were given to the subjects afterwards. The encounters are far from parodic of anthropological disinterestedness (within which numerous social encounters over and above the research undertaken frequently point out directions it might need to take). Lockhart also brings serial imagery into play: there is not one defining portrait but three, and the point is not laboured by making twelve.

Two other series were made on a river journey accompanying the anthropologist Ligia Simonian, who was making a survey of the river communities of the Rio Aripuanã region of the Amazon. The rooms in which the anthropologist had conducted her interviews were photographed empty of people, as though to enable the viewer to be nosy, to find out things about the family without them looking on. These works are pervaded by a great sense of calmness and indeed a beauty that recalls that of classic New Deal photography; but nothing is indicated by any of the works of the anthropologist's actual area of interest in her interviews. Lockhart also asked if the family owned any family photographs, and if some were produced she rephotographed them. These family snapshots then become the only representation of the subjects, a representation at two removes. The family photographs often show a formality, a use of photography as record, which recalls Lockhart's photographs from the series made with the families on Apeú-Salvador.

What these works by Lockhart might mean – I like to think, though this is too much to expect of one artist – is an end to the lazy and still too frequent denunciations of the anthropological and documentary traditions from those within the charmed circle of art. It is not as though these traditions have not already considered the problems that emerged within them and, from Mauss to Jean Rouch and beyond – truly too many names to mention – have not vividly been able to show a curiosity about others that is not coercive. Even Robert Flaherty's flagrant romanticism produced films that permit us to see other aspects of the societies shown, against the grain of the staged reconstructions, while more than a few anthropologists and documentarists have enabled the concerns of their subjects to be heard and represented in legal and political struggles. Lockhart's works show a capability of going over, at least to some extent – it is still under noticeable signs of restraint – to knowledge or imagination for another's point of view. Looking at the portrait series is discomforting because these people do so often seem to be

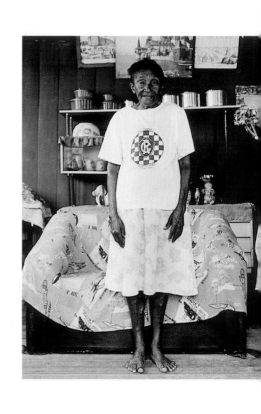

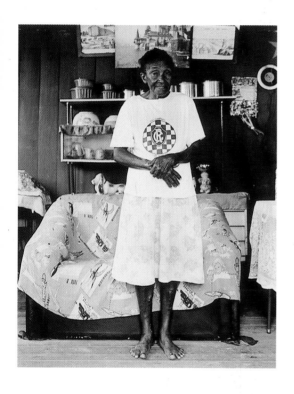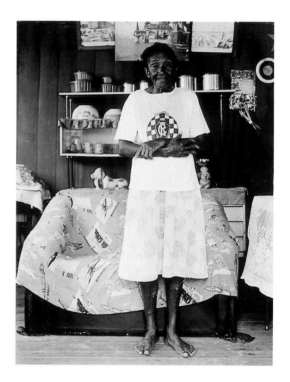

Sharon Lockhart *The Soares Family (December 24, 1998) Lucimar Barbosa Soares, Apeú-Salavador, Pará, Brazil, Survey of kinship relations in a fishing community, Anthropologists: Isabel Soares de Souza*, 1998

in possession of an honour so much greater than portraits of those more affluent would reveal, honour won by people who have known hard times and pleasure and will know both again. The strength of the ties of kinship that gets them through – and which it has often been a sign of development and of urbanisation to loosen – is also, we have to remember, a narrowing of their individual expectations and personal development. In villages and in close-knit urban communities around the world the relative lack of privacy and the knowledge that others may have of one's doings means that a constant effort needs to be made to perform the role that others allot and constantly reinforce according to age, gender, family position, etc.. The scope to change and reinvent oneself taken for granted elsewhere may simply not be available. The dignity visible in Lockhart's portraits is as real as the love that we intuit; but in these circumstances the love that accompanies ties of kinship cannot be other than strong.

The research of one of Lockhart's anthropologists concerned 'barter'. Behind the study of such varieties of exchange is a considerable body of knowledge. The feast system of the Indians west of the Rockies, often known as potlatch, is one of the most studied subjects in anthropological literature, and of course its equivalents have existed within European history. But it is not yet the intellectual property merely of social science. It is a political and economic institution which continues to flourish in some areas west of the Rockies, with differences, in the age of the pick-up truck and bingo. Both the aesthetic contours of the gift system, noted by Mauss in his great essay, and the social example of its subsistence, not least for those societies whose practice of it was placed under a legal ban, are profound.

There is much to learn from the old ways as they renew themselves and adapt and are reinvented against new opponents, by those who don't read books as by those who do. For those cultural workers who find a degree of solidarity and who learn respect for and knowledge of others within the temporary communities and international exchanges of the system of contemporary art – a small proportion of the free trade of goods and ideas – aspects of the social systems of tribes analysed by Mauss will be familiar.

Are the resources of art, which are social as well as aesthetic, being used to bolster solidarity with others outside the circle, and not as a dubious cultural replacement for other forms solidarity might take? What of the others, those who may have not yet heard about art or had the time to find uses for it? The various fleeting but recognisable contractualities being used by artists in their dealings with others may be a sign of maturity and good governance, after the illusions of community in so many forms of community art – and yet they may be a sign that those queasily sensed as 'outside' art (though involved in life) are governed in their supposed interventions into it by in-group customs they are not privy to. It should not perhaps be a surprise if that is the case, and that an admission of such exclusions even at the heart of the process of collaboration is a necessary part of the work of those artists who adopt an investigatory role, as it was a part of the anthropological and documentary traditions that preceded them: formal structures of knowing from which empathy is not, finally, excluded.

1 Marcel Mauss, *The Gift: the form and reason for exchange in archaic societies*, translated by W.D. Halls, London: Routledge, 1990. First published in 1924 in *Année Sociologique*, 2nd series.
2 Boris Mikhailov, *Case Histories*, Zurich: Scalo Press, 1999.
3 Gilda Williams, "Boris Mikhailov", *Art Monthly* 237, June 2000. Reviewing the exhibition of *Case Histories* at The Photographers' Gallery, London. Coincidentally another contributor to *Art Monthly,* Dave Beech, wrote this year of his sister's experiences working amongst children living near Chernobyl. The thing that he found shocked him most was that many of the children had never been photographed before.
4 Sharon Lockhart, *Teatro Amazonas*, Rotterdam: Museum Boijmans Van Beuningen/NAi Publishers, 1999.
 See also my review of the exhibition, *frieze* 52, May 2000, and Joe Scanlan, "Let's Play Prisoners", *frieze* 30, October 1996.

ACKNOWLEDGEMENTS

Alfredo Jaar, Philip-Lorca diCorcia, Mierle Laderman Ukeles,
Jennifer Bornstein, Roderick Buchanan, Adam Chodzko, Richard Billingham,
Tom Hunter, Sharon Lockhart, Rineke Dijkstra, Tracey Moffatt,
Boris Mikhailov, Juergen Teller.

Marc Nochella at Ronald Feldman Fine Arts, Alissa Schoenfeld at
Pace/MacGill Gallery, Mary Sabatino at Galerie Lelong, Cornelia Grassi
at greengrassi, Kate Bush at The Photographers' Gallery, Lehmann Maupin
Gallery, Anthony Reynolds Gallery, The Saatchi Gallery, Victoria Miro Gallery,
Neugerriemschneider Berlin, Kim Sweet, Halla Beloof, Lydia Papadimitriou,
Theodoros.

Publication made possible through financial contribution by
The University of Derby, Oxford Brookes University and Site Gallery, Sheffield.

COLOPHON

Face On: Photography as Social Exchange

Edited by Craig Richardson and Mark Durden.
Designed by Linda Byrne.
Produced by Duncan McCorquodale.

Printed in the European Union.

ISBN 1 901033 37 6

British Library cataloguing-in-publication data.
A catalogue record for this book is available from The British Library.

Black Dog Publishing Limited
PO Box 3082
London NW1 UK
t 44 020 7613 1922
f 44 020 7613 1944
e info@bdp.demon.co.uk